BARK

BARK

Georges Didi-Huberman

translated by Samuel E. Martin

THE MIT PRESS Cambridge, Massachusetts London, England

This book was set in Sabon and Monotyope Grotesque by The MIT Press. Printed and bound in the United States of America.

Library of Congress Cataloging-in-Publication Data

Names: Didi-Huberman, Georges, author.

Title: Bark / Georges Didi-Huberman ; translated by Samuel E. Martin.

Other titles: Écorces. English

Description: Cambridge, MA : The MIT Press, 2017.

Identifiers: LCCN 2017005340 | ISBN 9780262036849 (hardcover : alkaline paper)

Subjects: LCSH: Birkenau (Concentration camp) | Auschwitz (Concentration camp) | Didi-Huberman, Georges--Travel--Poland. | Birkenau (Concentration camp)--Pictorial works. | Auschwitz (Concentration camp)-- Pictorial works. | Holocaust, Jewish (1939-1945)--Poland.

Classification: LCC D805.5.B57 D5313 2017 | DDC 940.53/1853862--dc23

LC record available at https://lccn.loc.gov/2017005340

10 9 8 7 6 5 4 3 2 1

Abode where lost bodies roam each searching for its lost one. Vast enough for search to be in vain. Narrow enough for flight to be in vain. ... Then all go dead still. It is perhaps the end of their abode. A few seconds and all begins again. Consequences of this light for the searching eye. Consequences for the eye which having ceased to search is fastened to the ground or raised to the distant ceiling where none can be.

Samuel Beckett, *The Lost Ones*

TRANSLATOR'S NOTE

Bark holds a distinctive place among Georges Didi-Huberman's books, not so much by virtue of its short length (he has published shorter) or its deeply personal tone (even his most theoretical writing is characterized by a similar sense of intimacy), but because he has avoided the meticulous documentation that normally accompanies his texts. Given that *Bark* presents itself as something other than an academic study, I have elected to follow his lead; enough information is provided for the curious reader to locate Didi-Huberman's sources without difficulty. Likewise, in occasional instances where the translation does not convey an important wordplay or double meaning, I have provided the French term in parentheses, rather than intrude on the reader's attention with my own notes. Many translators have already spoken to the particular challenges of rendering Didi-Huberman's prose into English, and without wishing to repeat what has been said elsewhere, I remain grateful for their example.

My sincerest thanks to Georges Didi-Huberman, for his kindness and encouragement; to Victoria Hindley and Judy Feldmann at the MIT Press, for their wonderful patience and unwavering commitment to this project; to Mélanie Péron, without whose support I could not have undertaken it to begin with; and finally to John, Jan, and JR Martin, for their invaluable suggestions and attentiveness from start to finish. Any errors, inconsistencies, or oversights remaining in the text are very much my own.

BARK

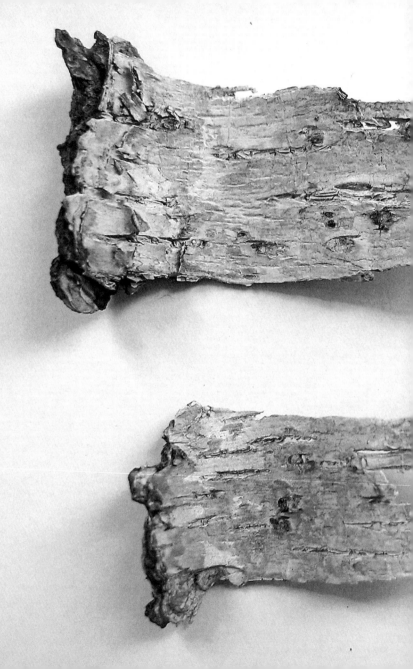

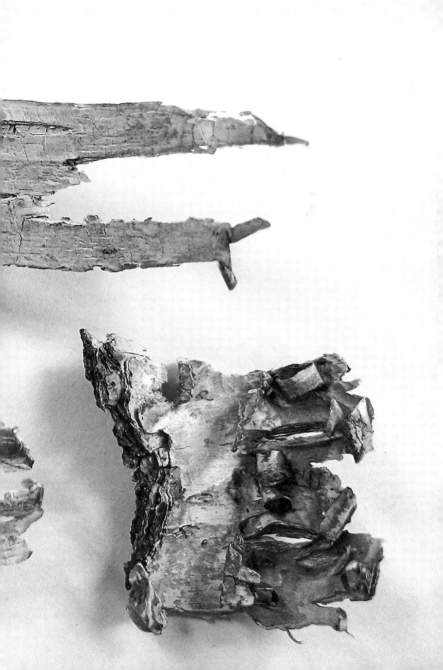

I placed three small pieces of bark on a sheet of paper and looked. I looked, with the idea that looking would perhaps help me to read something that had never been written. I looked upon the three small strips of bark as the three letters of a script preceding all alphabets. Or perhaps as the beginning of a letter—but to whom? I notice that I've spontaneously arranged them on the blank paper in the direction of my written language. Each "letter" starts on the left, where I dug my nails into the tree trunk to strip the bark away; then it flows to the right like a miserable flood, a broken path: this striated spreading, this bark tissue torn too soon.

These are three strips torn from a tree in Poland some weeks ago. Three strips of time. My time itself, in strips: a fragment of memory, this unwritten thing I attempt to read; a fragment of the present, here before my eyes on the blank page; a fragment of desire, a letter to write—but to whom?

Three strips whose surface is gray, almost white. Aged already. Characteristic of birch. It frays in scrolls, like the remains of a burned book. The other side is—as I write this—still pink like flesh. It adhered so well to the trunk. It resisted the bite of my nails. Trees, too, are attached to

their skin. I imagine that with the passage of time, these three strips of bark will be gray, almost white, on both sides. Will I keep them, put them away, forget them? And if so, in which envelope of my correspondence? On which shelf of my library? What will my child think when he comes across these remnants after my death?

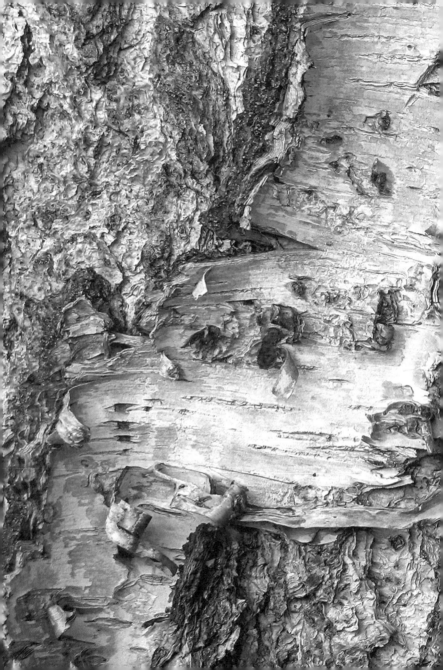

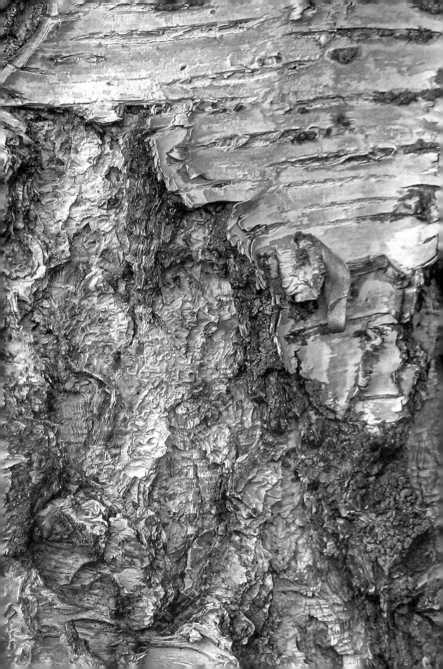

Birch trees from Birkenau: the trees themselves—"birches" are *Birken*, "birch wood" *Birkenwald*—gave their name to the place that those in charge of the Auschwitz camp wanted to devote particularly, as we know, to the extermination of the Jewish populations of Europe. In the word *Birkenau*, the ending *au* specifically designates the meadow where the birches grow; hence it's the name of the *place*. But it could also—already—be a name for *suffering* itself, as a friend with whom I was discussing these things pointed out to me: the exclamation *au!*, in German, corresponds to the most spontaneous cry of pain, like *aïe!* in French, or *¡ay!* in Spanish. The profound and often terrible music of words heavily invested with our dread. In Polish, they call it *Brzezinka*.

Birches are trees typical of barren, desolate, or siliceous lands. They are known as "pioneer plants" because they often constitute the first arboreal formation by which a forest begins to encroach on wild heath. They are very romantic trees, under whose shadow (in Russian literature, for example) countless love stories and poetic elegies unfold. Under the shadow of the birches of Birkenau—the very ones I photographed, for birches, which live no more than thirty

years in temperate countries, endure, here on Polish soil, up to a hundred years and more—unfolded the tumult of thousands of tragedies, attested to solely by a few manuscripts partially erased, buried in ash by the members of the *Sonderkommando*, those Jewish prisoners assigned to deal with the corpses and destined to die in turn.

I walked among the birches of Birkenau on a beautiful day in June. The sky was heavy. It was hot, nature was flourishing on all sides: innocent, brimming, persisting in its work of life. Bees swarming deliriously around the trees. The name for birch, in several Slavic languages, is associated with the renewal of springtime, evoking the sap that begins to circulate in the trees once more. In Russia at the beginning of June they observe "Green Week," which celebrates the fecundity of birches, the national tree. Birch is also the first tree of the Celtic calendar: it symbolizes wisdom, they say.

What consequences of this light for my searching eye? What consequences for my eye which, having ceased to search, was fastened to the ground or raised to the distant treetops?

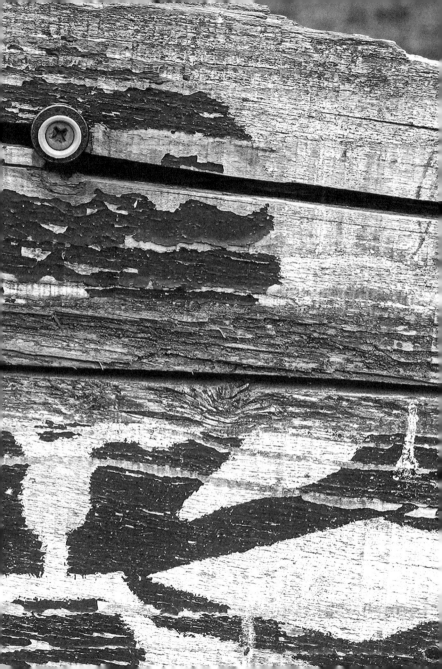

In antiquity, and then in the Middle Ages, birch bark was used as a medium for scripts and figures. A wooden board, painted white and marked with a skull, welcomes the visitor to this place dominated by wood, brick, cement, and barbed wire. Since 1945—since this warning ceased to have any immediate significance—the black and white paint has peeled, much like birch bark. But it remains quite legible, along with the time that has aged it. Some of the original nails have disappeared; the sign must have been recently fixed with modern screws.

I arrived at the Auschwitz-Birkenau complex on a Sunday morning, very early, at an hour when admittance is still free—such a strange adjective, if one thinks about it, but it's the adjective that gives meaning to each instant of our lives, an adjective one should know to mistrust when one sees it written in overly prominent characters, for example in the forged iron of the famous gate *Arbeit macht frei*—more precisely, at an hour when it's not yet required to make the visit under a guide's authority. The metal turnstiles, exactly the same as those in the subway, were still open. The hundreds of audio headsets still hanging on display. The "handicapped" hallway still closed off. The national

17

signs—*Polski*, *Deutsch*, *Slovensky* …—still lined up on the shelf. The *Kino* room still empty.

Here and there, other signs: the little green arrow on the wall after the turnstile, an arrow like the injunction not to deviate from the mandatory way, green like birch leaves, or like the indication that the way is "free." Signs to direct human traffic, just as there are everywhere, so many everywhere. I go on to read the word *Vorsicht* ("Attention!") struck through with a red lightning bolt and followed by the words *Hochspannung—Lebensgefahr*, which is to say "High tension" and "Danger to life" (meaning, of course, the danger of death). But today this word *Vorsicht* seems to me to resonate very differently: more like an invitation to turn one's sight (*Sicht*) to a "before" (*vor*) of space and time, a very cause of what one sees (as in the expression *vor Hunger sterben*, "to die of hunger"). That cause, or "original thing" (*Ursache*), whose efficiency when directed toward the "thing" of the camps is endlessly scrutinized.

Still other signs spring up all around: so-called memorial steles on which texts written in white—in Polish, English, and Hebrew—stand out against a black background. Or, more prosaically, signs with the familiar look of "no entry": no talking; no swimwear during the visit; no smoking; no eating, no drinking (the image, crossed out with a red line, of a hamburger next to a large cup of Coke); do not use your cell phone; keep your transistor radio turned off; do not wheel your suitcase through the camp; do not push a stroller;

no flash photography or video cameras in the interior of the blocks; no dogs allowed.

This barracks at the Auschwitz camp has been transformed into a commercial stand: it sells guidebooks, cassettes, books of testimony, and pedagogical works on the Nazi concentration camp system. It even sells an extremely vulgar comic strip that appears to recount the love between a female prisoner and a camp guard. It's a bit soon to rejoice completely, then. Auschwitz as *Lager*, this place of barbarism, has doubtless been transformed into a place of culture, Auschwitz as "State Museum," and so much the better. It's simply a question of determining the type of culture that this place of barbarism has come to exemplify.

There would seem to be no link between a struggle for life, for survival (*survie*), in a "place of barbarism," which Auschwitz was as a camp, and a debate over cultural forms of survival (*survivance*) in the context of a "place of culture," which Auschwitz is as a state museum today. There is a link nonetheless. The place of barbarism was made possible—for it was conceived, organized, and sustained by the physical and spiritual energy of all those who worked there to deny life to millions of people—by a certain culture: an anthropological and philosophical culture (race, for instance), a political culture (nationalism, for instance),

even an aesthetic culture (which enabled it to be said, for
instance, that one kind of art could be "Aryan" and another
"degenerate"). Culture is not the cherry on the cake of history:
it remains ever a place of conflict, where history itself
acquires form and visibility at the very heart of decisions
and acts, however "barbarous" or "primitive"
they may be.

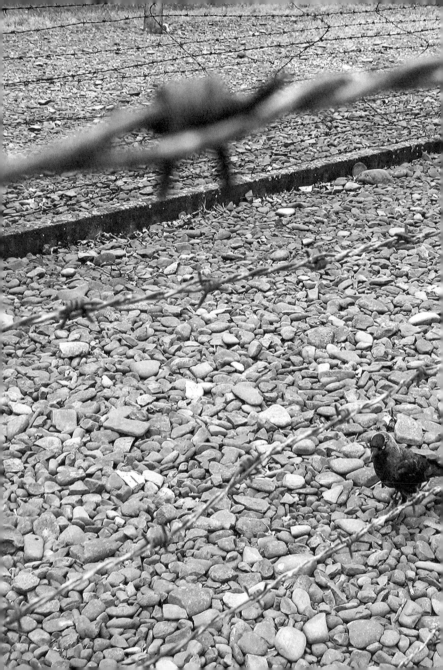

I was walking near the barbed wire when a bird landed beside me. Just alongside—but on the other side. I took a photograph without really pausing to think, probably touched by the freedom of this animal who made light of the enclosures. The memory of the butterflies drawn in 1942 in the Theresienstadt camp by Eva Bulová, a child of twelve who was to die here at Auschwitz in early October 1944, probably flashed through my mind. But today, looking at this image, I notice something else altogether: in the background is the electrified barbed wire of the camp, its metal already dark and rusty, and arranged according to a very particular "braid" that doesn't appear on the barbed wire in the foreground. The latter's color, light gray, indicates to me that it has only recently been installed.

Realizing this makes my heart ache. This signifies that Auschwitz the "place of barbarism" (the camp) installed the background wire during the 1940s, whereas the wire in the foreground has been placed there by Auschwitz the "place of culture" (the museum) far more recently. For what reason? Is it to orient the flow of visitors, using the barbed wire as "local color"? Is it to "restore" an enclosure that had deteriorated over time? I can't be sure.

But I do have the distinct feeling that the bird landed between two terribly disjointed temporalities, two very different arrangements of the same parcel of space and history. The bird landed, without knowing it, between barbarism and culture.

The famous "execution wall" at Auschwitz is situated between blocks 10 and 11. On the ground floor of the latter, a small SS "service room" had been set up, which functioned as a criminal court for the Gestapo of Katowice, along with the rooms where prisoners awaited their execution: rooms, we are told, that have been "reconstructed." Below ground were the prison cells of the *Stammlager*, or "principal camp" (the word *Stamm* actually refers to the trunk of a tree and so denotes something's essence or genealogical connection, as in the expression *der Apfel fällt nicht weit vom Stamm*, which corresponds to our expression "the apple doesn't fall far from the tree"). At the top of the walls, one can still see the remains of heating pipes. One can see the tiny oubliettes where the prisoners, deprived of everything—food, air, light—perished of hunger and thirst.

The "execution wall" (*Erschiessungswand*), also called the "death wall," was in its day painted black. It was made up of slabs of cement, sand, and wood, materials intended to dampen the ricochet of bullets. As to the wall I now see—where various visitors have left a white stone, a funeral wreath, an artificial rose, or a pious image—it's made of an agglomerate of gray fibers dipped in a coating, plaster or

liquid cement. It calls to mind an insulating material or a theater wall. The unpleasant sensation—for here no inscription tells me about the reality of what I'm seeing—that the walls of Auschwitz don't always tell the truth.

The unpleasant sensation of seeing the blocks of the camp—blocks 13 to 21—transformed into "national pavilions," as at the Venice Biennale which is being held at the very moment that I walk through this place. Here above all, the walls lie: once inside the block, I can no longer see anything of what a block is, everything having been "refurbished" as an exhibition space. The Polish pavilion, with its large pedagogical pictures and national bombast; the Italian pavilion, with its cable-molded interior architecture, as if it had required a decorative fantasy to convey its historical message; the French pavilion, with its "scenario" by Annette Wieviorka, its "scenography" and "graphic design," its unnecessary shadow figures drawn on the wall, its installation imitating a work by Christian Boltanski, and its poster for Claude Lanzmann's film *Shoah*. Annette Wieviorka's books are more necessary than ever in libraries, and Claude Lanzmann's film remains more necessary than ever in movie theaters. All places of culture—libraries, movie theaters, museums—can contribute throughout the world toward building a memory of Auschwitz; that goes without saying. But what can you say when Auschwitz must be forgotten at its very site in order to constitute itself as a fictitious place devoted to Auschwitz's memory?

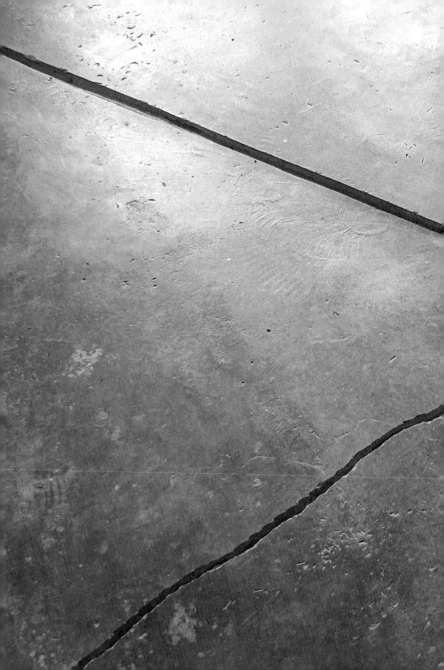

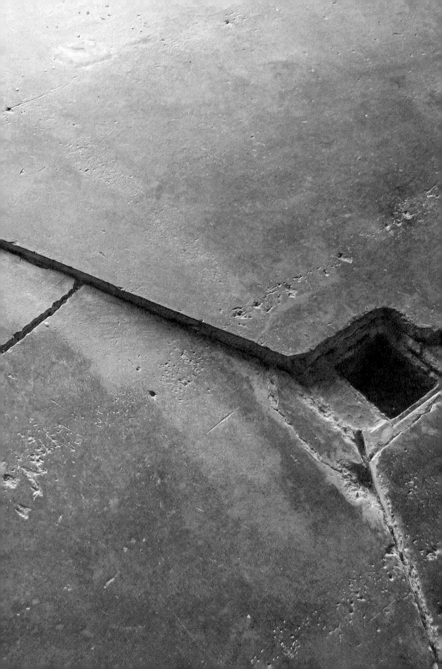

Birkenau is something else entirely. Here the walls hardly exist anymore. But the scale doesn't lie, and hits you with extraordinary force—a force of desolation, of terror. Nor does the ground lie. Auschwitz today aspires to be a museum, while Birkenau remains little more than an archaeological site. At least, that's how it appears when one looks at what there is left to see where nearly everything has been destroyed: for example, these floors that have been worn out, wounded, riddled, cracked. Floors that have been gashed, gouged, opened up. These cloven floors fractured by history, these floors that can make you cry out.

A place such as this demands of its visitor that he reflect at some point on his own acts of looking. I've noticed over time that a certain configuration of my own body—short in height, eyes that remain near-sighted in spite of glasses, and a certain fundamental fear—was prompting me to look mostly at things close to the ground. As a general rule I walk with my eyes downcast. Something must have persisted of a very old (not to say childish) fear of falling. But also of a certain propensity to shame, such that for a long time, looking straight ahead was as difficult for me—I had the feeling that it required real courage—as it was necessary. This resulted almost naturally in a series of imperceptible gestures intended

to focus, rather than to diffuse, my visual field. Hence I've acquired the habit of transforming this general timidity in the face of things, this desire to flee or to remain in perpetually vacillating attention, into the observation of all that is low: the first things to see, the things "under one's nose," the down-to-earth things. As if stooping to look somehow helped me to better think about what I see. At Birkenau, a particular dejection in the face of history no doubt made me lower my head slightly more than usual.

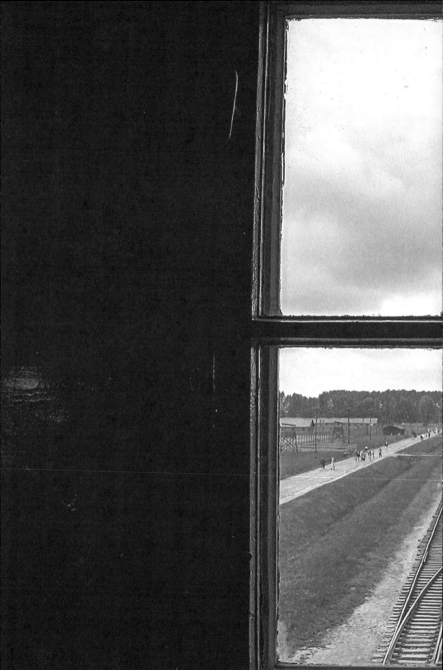

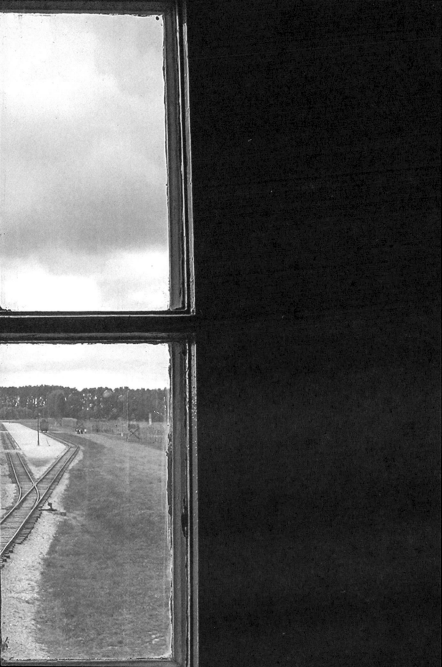

And so I went to Birkenau. Like so many others—the thousands of tourists, the thousands of pilgrims or the few hundred survivors, the latter sometimes mistaken for the former and vice versa—I "visit" this capital of the evil that man can do to man. What's the sense in it? And why write it? Haven't I long been persuaded that this would be impossible for me? And yet it's so easy to take the plane to Warsaw, the train to Krakow, the bus to Auschwitz, and the shuttle to Birkenau. Although some eight hundred people named Huberman are listed on the death registry of the Shoah, I am not in the situation of "returning" to Auschwitz-Birkenau, as Paula Biren, a survivor of the camp, could legitimately say before Claude Lanzmann's video camera: "I've often wanted to. But what would I see? How would I face up to that? […] How can I return to that, for a visit?"

And so I passed through the doorway of what was once hell, and what was so calm and quiet on that Sunday morning. I climbed the main watchtower. I photographed the window that looks out on the selection ramp. My friend Henri, who was accompanying me—and whose gentle insistence had induced me to undertake this trip—tells me he heard me say, "It's inconceivable." I said it, of course, I said

it like everyone else. But if I must continue to write, to look, to frame, to photograph, to arrange my images, and to think all of this, it's precisely in order to render such a phrase incomplete. One should say instead, "It's inconceivable, so I must conceive of it in spite of everything." To picture something of it, at least, the bare minimum of what we can know of it.

I looked, it was inconceivable, and at the same time so simple. When I came upon the selection ramp over there—with a sparse group of visitors on the path opposite—I distinctly felt the inconceivability of past reality (the tragedy of the selections) along with the inconceivability of a past viewpoint (the observation by the SS guard, from the same window, of the proper functioning of things). This inconceivability was the victims' powerlessness to form a clear picture of the minutes that were to follow, which would consummate (consume) their fate. Or, indeed, the refusal of the SS guard to imagine the humanity of those men, women, and children whom he observed from on high and far off. But today, for me on this page, for anyone faced with a history book or on the territory of Auschwitz, it is necessary not to remain at this impasse of the imagination, the impasse that was precisely one of the great strategic forces—*via* the lies and brutality—of the Nazi extermination system.

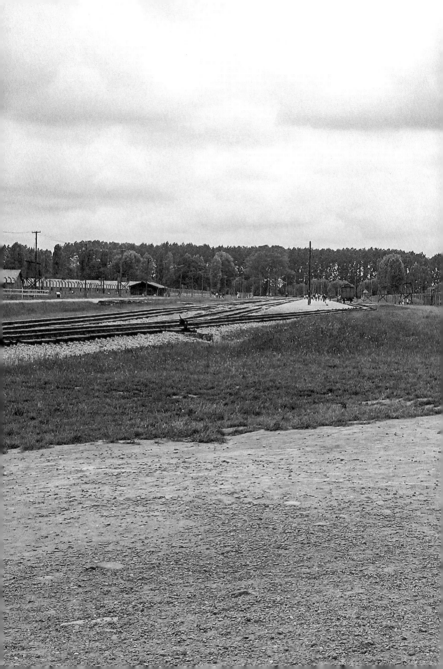

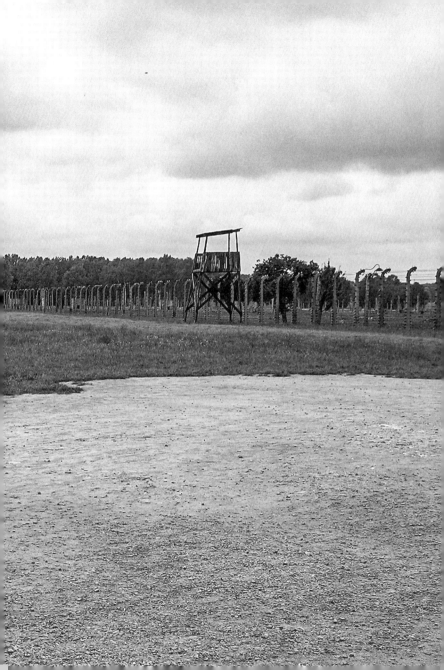

From that moment on, I photographed practically everything without looking. First, because a kind of urgency propelled me forward. Second, because I had no wish to transform this place into a series of well-framed landscapes. Finally, any precise framing was all but impossible, technically speaking, insofar as the gloomy light of midday, whose intensity, or at least whose leaden weight, was almost accentuated by the clouds in the sky, prevented me from checking anything on the small monitor screen of my digital camera.

But what is a horizon at Birkenau? What is a horizon in this place conceived to shatter all hope? The horizon is first of all those desolate patches of land—desolate today, back then teeming with a terrorized population—dominated by the watchtowers. Right over there, to be sure, is the crest line of the forest trees. One therefore has to try to project one's gaze as far as possible, beyond the electrified enclosures of the camp, to where nature "reasserts its rights," as they say in French, and where perhaps there still exist human rights, the negation of which this very place managed so efficiently. But the horizon here comprises first of all the horizontal lines of the barbed wire—twenty rows or thereabouts—which,

standing tall as a man, imprisons sight wherever one is, just as it does life.

The whole space is crossed out, scored, gashed, struck through, mangled by the barbed wire. Bristling horizontal lines, put there not so that one can get one's bearings, as in an optical apparatus with a grid view, but rather so that one give up altogether. It is thus a horizon beyond all orientation or disorientation. It is a lying horizon, where the opening out toward the distance collides with the implacable enclosure of the barbed wire. Unlike a prison—which, in theory, is a juridical space, whose enclosure takes the form of opaque walls—the Birkenau camp is all the more closed off in its negation of rights for its being visually "open" toward the exterior.

Today, now that nearly everything has been destroyed—notably the crematoriums, dynamited by the SS between the 20th and the 22nd of January 1945, just before the arrival of the first soldiers of the Red Army on the 27th—the horizon of Birkenau is more firmly situated between the wooden barracks still there, the bristling stakes of the enclosure, and the vestiges of all that has been demolished. This is why the ground assumes such importance for a visitor to this place. One has to look as an archaeologist looks: in this vegetation lies an immense human desolation; in these rectangular foundations and these heaps of bricks lies all the horror of the mass gassings; in this aberrant toponymy—"Kanada," "Mexiko"—lies all the crazy logic of a rational organization

of humanity conceived as a material, a residue to be transformed; in these tranquil marshy surfaces lie the ashes of countless people murdered.

I entered the barracks that were still intact (if one can put it that way). Spaces at once vast and confined. Now that there is no longer anyone there to suffer, to moan, to die, or to survive, one is still struck by something like the state preceding this human condition: by that I mean the method of construction, its simplicity, its cruel poverty, its stable-like logic. The brick and cement were below, for the floor, latrines, pipes, and chimneys. All the rest is in wood: nothing but beams and boards. The crude joinery of the bedsteads. The black walnut stain of the walls, typical of peasant construction in Poland. The closing system of the doors.

To photograph this is inevitably to produce images with appalling perspective: they are long buildings, where, for example, the rudimentary latrine holes appear in endless succession. One understands why the most evident cinematic form in a place like this was the tracking shot adopted by Alain Resnais in *Night and Fog* (distinct from the pans and long shots of Claude Lanzmann when, in *Shoah*, he filmed the "non-places" of the extermination sites where no construction remained). Moreover, the tracking shot requires a rail and thereby bears a resemblance to the railway mechanism itself, that mechanism essential to the "Final

Solution" because—as Raul Hilberg has shown—it was a matter of managing the transport of the Jewish populations from all over Europe to this fatal "ramp" at Birkenau.

A human stable, of which I photograph only the door— which is like the unmoving shot, the "Halt! Who goes there?" of all perspectives; was this barracks, on the whole, anything other than one more gigantic cattle wagon? The last wagon, the wagon come to a stop, the space of an infernal life while awaiting worse to come?

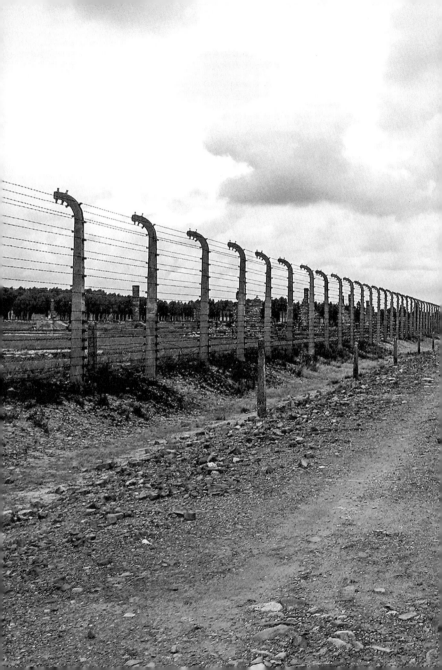

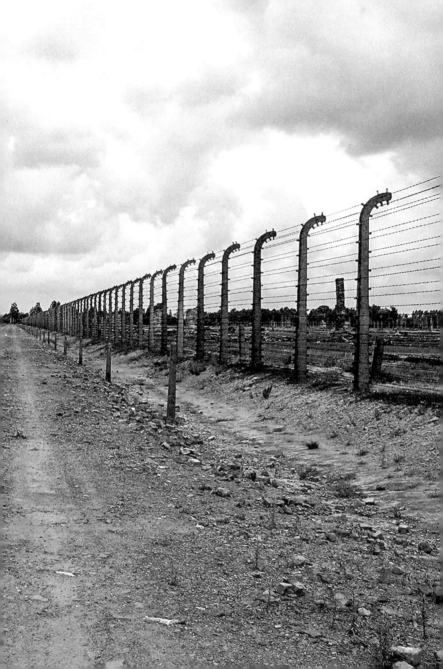

It's here above all, that appalling perspective. This is the way—the "camp road" called *Lagerstrasse A* by the Nazi officials—that led either toward the *Zentralsauna* for the "fit" who would be stripped of their clothes, disinfected with Zyklon B, tattooed, and so on, or else toward crematoriums IV and V for the "unfit" destined for immediate gassing with mortal doses of the same Zyklon B. Another way, called *Hauptstrasse* or "main road," directed the newly arrived "unfit" toward the large crematoriums II and III.

It was on this road, after the "selection" on the *Judenramp*, that a Nazi official took up a position, between May and June 1944, to photograph those arriving in the convoys of Hungarian Jews, and notably those "unfit"—women, children, the elderly—who were led directly to death. On this peaceful Sunday in June 2011, the road is empty: not a single tourist on the horizon. It's merely a stony route to get from the railway zone of the camp to the zone of the gas chambers. The picture I take of it, with cursory aim and a simple movement of my finger, is ultimately far more artful (despite its considerable banality), far more complex than all that one can say when one *expects everything* from a photograph ("Yes, there it is, that's it!"), or when on the

contrary one *no longer expects anything* from it ("No, that's not it, because it's inconceivable").

An archaeological point of view suffices to remove the false dilemmas posed by these alternatives. Yes, it is indeed here, yes, this is it, still resisting time: it is indeed this road, this path, it is indeed those two rows of concrete pillars fitted with barbed wire. This is indeed the place of our history. But this place henceforth is empty of all the actors in its tragedy. The fire of history is gone. Gone with the smoke of the crematoriums, buried with the ashes of the dead. Is this to say that there's nothing to imagine because there's nothing—or so little—to see? Certainly not. To look at things from an archaeological point of view is to compare what we see in the present, which has survived, with what we know to have disappeared.

One does not tell the truth with words (each word can lie, each word can mean anything and its opposite), but with phrases. My photograph of the "camp road" is still just a meager word. Hence it asks to be situated in a phrase. Here, the phrase is none other than my entire narrative, a narrative of words and images unseparated. But a single word takes on meaning only by being used in contexts that one has to know how to vary, to *test* (*éprouver*): different contexts, different phrases and montages. For instance, the montage that would consist, having paced up and down this road alone, in scrutinizing the faces of those who passed along it one day in May or June 1944: those faces that the

Nazi officer photographed without looking, but who look at us today from the appalling pages—prosaic and petrifying, so simple and vertiginous at the same time—of the *Auschwitz Album*.

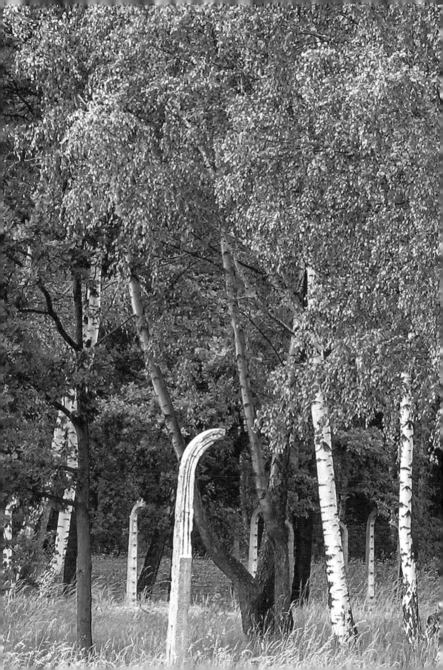

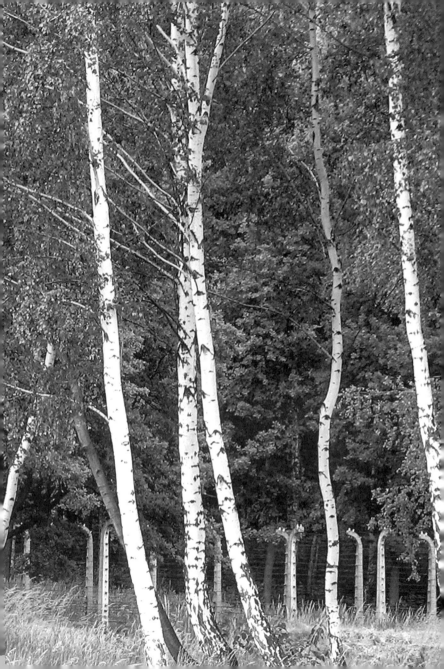

One has to walk for a while. At the end of the *Lagerstrasse A*, one passes again under a new wire-netted gate. Then one has to take a left on the *Lagerstrasse B*, prolonged—everything is so empty here, but these place names clearly indicate that we are in a city, an immense city of ghosts—by the *Ringstrasse*. It's there that the *Birkenwald*, or birch wood, begins. It appears in all its verdant serenity (it must be quite different in winter), with white tree trunks of such delicate beauty, their markings calling to mind the remains of some musical score. In a few of my photographs you can see only the trees, as if my gaze had sought to breathe beyond the barbed wires. But the barbed wires are still there, with their cement stakes and their electrical conductors. All this, rendered so inconspicuous by the visual force of the surrounding tree trunks, yet so present, since the trunks indicate a place of organized massacre in this banal forest.

We're very close to crematoriums IV and V. In the plates of the *Auschwitz Album* assembled by the Nazi photographer in the chapter on the "unadapted," one can see dozens of women and children grouped together among the trees, sitting on the grass; an inattentive glance might situate them in a giant picnic scene (in reality they are not eating, they

are waiting, and those one sees with their hands over their mouths have only that gesture for the anguish that grips them before the intimidating lens of the SS). In the background, one occasionally sees the electrified stakes. But the tree trunks are already like the bars of an immense prison, or rather, like the links of a siege trap.

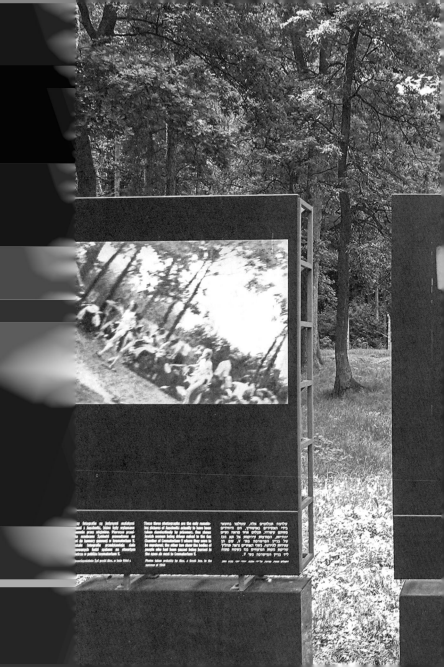

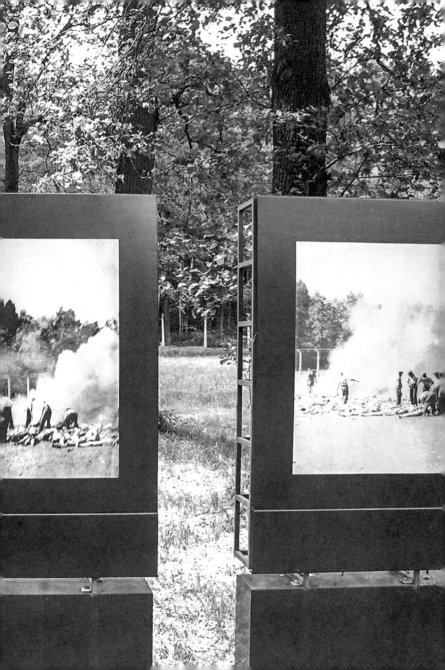

The site of crematorium V creates a kind of clearing in the birch wood. In November 1942, the construction work began, and by April 5, 1943, the SS was able to organize a first mass gassing. Today's visitor sees hardly anything except what the Soviets saw in January 1945: a simple ruin, a pile of rubble in front of which a small "wrong way" sign urges us not to "enter."

We know the Russians attempted to clear away those remains, perhaps with the idea of bringing to light what was left of the crematory oven, made—like all the others—by the honorable firm Topf und Söhne, which initially specialized in providing equipment for the brewing industry or for cereal roasting. But as the explosive charges had been placed inside those very ovens, all that remained were shapeless piles of bricks and scrap iron. Today, a notice installed in front of the rubble gives the exact configuration of the building; the officials of the *Bauleitung*, the construction service for the camp, did not have the time in 1945 to burn all of the plans.

It was here in August 1944 that a member of the *Sonderkommando*, assisted by all his comrades, took the four photographs that constitute the only visual testimony to this day of a gassing operation at the time of its actual unfolding.

Testimony produced by the prisoners themselves, and meant to be transmitted, like the famous "*Sonderkommando* manuscripts," beyond the closed world—the implacable sealing off of space and implacable inevitability of time—that was Birkenau. The exceptional nature of these documents prompted the curators of the State Museum of Auschwitz-Birkenau to install three steles just opposite the ruins, reproducing the photographs and summarizing the conditions in which they were taken.

It's now been more than ten years since I devoted a written work to these photographs: an essay, an attempt to look at them closely, to sketch their phenomenology, to situate their historical content, to understand their stunning value for our very thought. This was not without problems: intrinsic difficulties of confronting such images, extrinsic difficulties of confronting a controversy stemming from the very fact of according them such importance. These difficulties are not my own: they accompany, I think, every "cultural" decision linked to the transmission and the museification of a historical event whose stakes—memorial, social, philosophical, and political—are significant.

Briefly, then, here is the situation in this clearing in the birch wood: on one side is a charming verdant forest, and on the other a large pile of bricks and scrap iron, which is to say, all that remains of crematorium V of Birkenau where, outside all human law, thousands of people were murdered. Between the two stand the three photographic steles, these so-called

lieux de mémoire, supplemented by four more black steles a few feet away: they are engraved with white letters in four languages, where one can read the words "memory," "victims," "genocide," "ashes," and the expression "rest in peace." One can also see red roses and the small funerary stones of Jewish tradition, delicately placed here by passing pilgrims.

As someone already familiar with these photographs, I'm evidently struck by the process they have undergone in order to attain, on these steles, the status of *lieux de mémoire*. I have no wish to speak here as a finicky "specialist"—which I'm not. To my mind simply comes this question, the most obvious one there can be: Is it therefore necessary to simplify in order to transmit? To prettify in order to educate? More radically, you could ask: Must one lie in order to tell the truth? And who, then, would take it upon himself to answer these questions in the affirmative? If I remember rightly, on the lower floor of the Memorial to the Murdered Jews of Europe, in Berlin, the documents are presented in a spirit of scrupulous exactness: the letters of deportees have been photographed, transcribed, and translated for the visitor who, as a result, receives their full material truth with full emotional force (for these letters are deeply affecting, and philological scrupulousness will hardly have reduced their capacity to move us—quite the opposite).

Here, on the other hand, and as in so many other history books or "museums of memory," the photographs of the

Sonderkommando have been simplified, thus betraying the very conditions of their existence. First of all, we are told of—and shown—three photographs of the four that have actually come down to us. What harm, then, does the fourth image, which has become invisible, do to the other three? We know the extremely dangerous conditions incurred by the covert photographer of Birkenau, especially at the moment when outside the crematorium—only a few meters from a watchtower that still stands at the spot—he decided to capture the desperate running of the women being led toward the gas chamber.

The photograph missing from these steles had merely been an *attempt* to capture this running: unable to frame—that is, to take the camera out of the bucket where he was concealing it—unable to bring the viewfinder up to his eye, the member of the *Sonderkommando* pointed his camera as best he could toward the trees, blindly. He of course didn't know what this would yield in the image. What we are able to recognize today are the trees of the birch forest: just the trees, their boughs thrust toward the sky, and the overexposed light of that day in August 1944.

For those of us who accept to look at it, this "failed," "abstract," or "disoriented" photograph testifies to something that remains essential: It testifies to danger itself, the vital *danger of seeing* what was happening at Birkenau. It testifies to the situation of urgency, and to the near impossibility of testifying at that precise moment in history.

For the organizer of the *lieu de mémoire*, this photograph is useless, because it's missing the referent that it was targeting: nobody can be seen in this image. Yet must one have a clearly visible—or legible—reality in order for testimony to take place?

As for the three photographs remaining, I perceive right away that they've been reframed so as to make the reality to which they testify more "legible": the image of the women running toward the gas chamber here is merely a "close-up" taken from the real photograph of which the birch wood itself occupied a far greater part. The two images showing the cremation of the bodies in the open air have been "corrected" so as to suppress precisely what had made them possible: namely, the slanting angle and the substantial darkness—that of the gas chamber itself—thanks to which the covert photographer was able to take out his camera and frame his shot. Indeed, he had to *hide in order to see*, and curiously this is what memorial pedagogy would have us forget here.

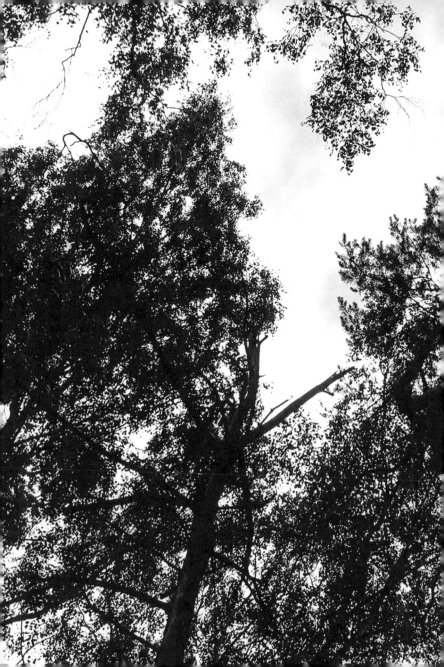

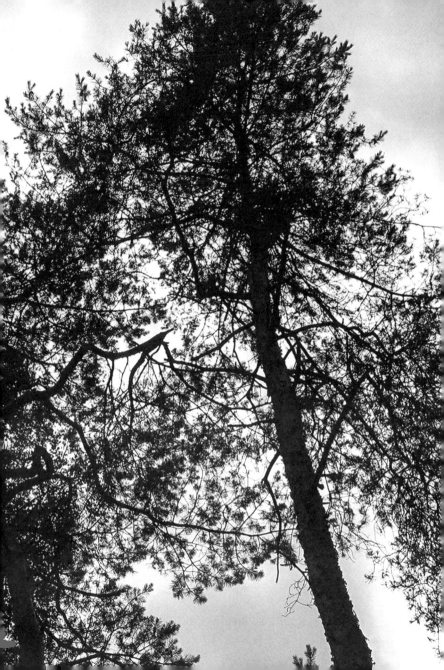

I looked toward the sky. On that June afternoon when it was leaden, the color of ash, I felt the implacable light the way one receives a blow. The birch boughs above my head. I took one or two photographs blindly, without really knowing why—at that moment I had no plan for a work, an argument, a narrative—but today I can see clearly that these images are addressing a silent question to the trees of the *Birkenwald*. A question asked of the birches themselves— the only survivors that continue to grow here, if one thinks about it. Comparing my image with that of the covert photographer of Birkenau, I note that the trunks of the birches are now much thicker, much more solid than they were in August 1944.

Memory does not only appeal to our capacity to provide detailed recollections. The major witnesses of this history— David Szmulewski, Zalmen Gradowski, Lejb Langfus, Zalmen Lewental, Yakov Gabbay, or Filip Müller—have passed on to us just as many affects as representations, as many fleeting, unconsidered impressions as declared facts. This is what makes their style matter to us, what makes their language move us deeply. In the same way, the urgent choices of the covert photographer of Birkenau matter

to us and move us, choices made in order to give visual consistency—where the unrecognizable vies with the recognizable, as the shadow vies with the light—to give *form* to his desperate testimony.

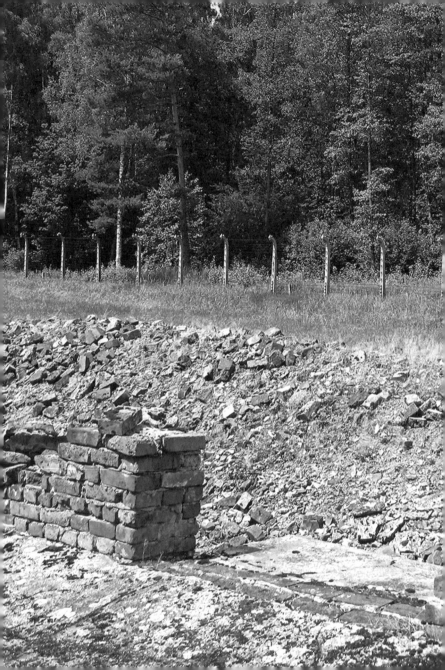

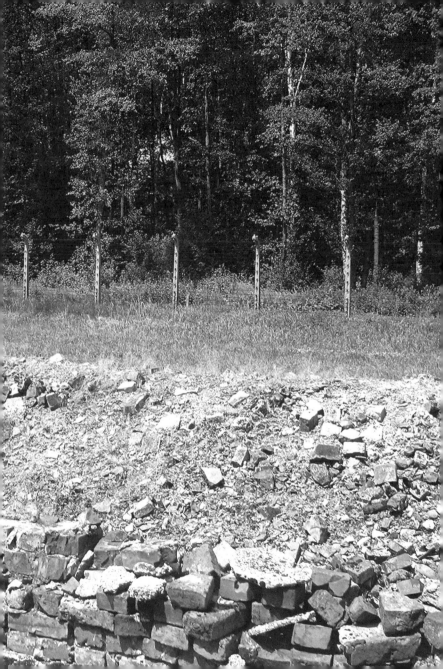

I wandered for a long time, not noticing the sign prohibiting it, among the silent ruins of crematorium V, that desolation "in the free air"—an expression I already regret, such is its resonance with the paradox resulting from the cruelty, the caging—and killing—inherent to such a place. The sky above was heavy; a breeze blew all around. The clearly visible foundations, the persistence of several rows of bricks—all of this allowed me, as if by an inversion of the landscape open before me, to imagine the walls and the ceilings of this building where so many human lives were snuffed out. One can see the forest just opposite, extending serenely beyond the barbed wire enclosure.

As it happens, the image I subsequently produced adopts an angle not unlike the point of view adopted formerly by the covert photographer of Birkenau (I'm leaving aside a question of orientation that I've attempted to elaborate elsewhere: the question of whether the vanished negative used to make the contact sheet preserved in the Auschwitz museum was inverted). The rectangular format of my image simply cuts off the view in the birch boughs, where the square format of the camera used by the member of the

Sonderkommando allowed a bit of sky to appear above those same trees.

In spite of the vehement and persistent denials of Claude Lanzmann—whether they be due to some metaphysical argument or more simply to the bad faith of one who always wants to be, or to have been, right—here, in the midst of this heap of rubble and these foundation lines, a terrible truth emerges, one that I'd established based on both an analysis of the construction plans of the crematoriums and the vital testimony provided by David Szmulewski, the only survivor of this episode, who was responding in 1987 to the meticulous questions of Jean-Claude Pressac. A terrible truth which the aerial images of the RAF, taken on August 23, 1944, but only recently come to light, will have supported with another point of view. The fact is that the two photographs by the *Sonderkommando*, where one sees the cremation of the bodies on the opposite embankment, were indeed taken from a gas chamber, its door open toward the north side, Szmulewski explained, for ventilation purposes. That very door only the broken threshold of which can be observed today.

Why should such a proposition have unleashed so much resistance, so much anger, and so many questionable inferences? The answer doubtless lies in the different use values with which one chooses to associate the expression "gas chamber" in today's discourses on the great massacre of European Jews during the Second World War. To a

metaphysician of the Shoah, "gas chamber" signifies the heart of a tragedy and of a mystery: the ultimate place of *the absence of witnesses*, analogous, if you will, in its radical invisibility, to the empty center of the Holy of Holies.

It must be said on the contrary, without fearing the terrible meaning assumed by words when one associates them with their materiality, that the gas chamber, to a member of the *Sonderkommando*, was the more or less daily "workplace," the infernal place of the *witness's work* (whether the witness miraculously survived, as did Filip Müller, or whether he died like all the others, but not before ensuring, as did Zalmen Gradowski, that the narrative of his condition would survive). The covert photographer's act was, all in all, as simple as it was heroic: by taking up his position in the gas chamber, precisely where the SS compelled him day after day to get rid of the corpses of the victims only just murdered, for a few rare seconds snatched from the attention of his guards, he transformed the *work of servitude*, his work as a slave in hell, into a veritable *work of resistance*.

For those of us today who attempt unsuccessfully to measure the horror of the mass murders, the gas chamber *signifies* first of all the *absolute* center of the "Final Solution." But the real conditions of such a process—always material, trivial, circumstantial—are never absolute; as such, the gas chamber *existed* for each person in the *relative*, cruelly relative network of the "selections," the decisions of the SS, and, generally, the countless conditions where each

fate could vary and bifurcate, however slightly, at the very heart of that implacable horizon of death. Must not the act of the covert photographer of Birkenau, who used the threshold of the gas chamber as a momentary shelter and a slanted frame for his act of witnessing, consequently be understood as that minuscule bifurcation of his work of death into a work of looking?

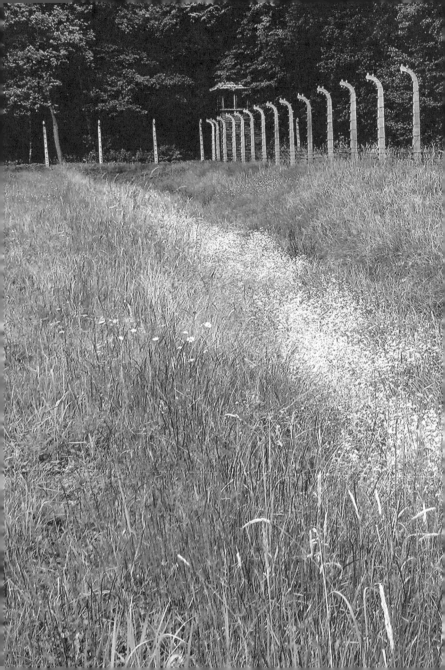

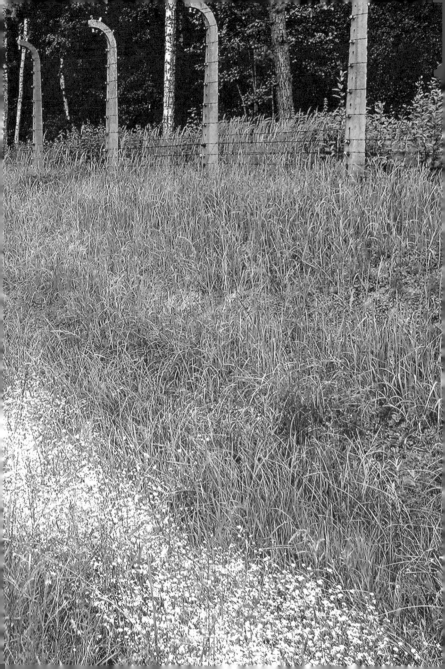

I then ventured near to the enclosure, heading north. Here, at the angle of the perimeter established for this zone of Birkenau, one sees the watchtower that was no doubt the object of all the *Sonderkommando* members' worries during their covert picture-taking operation. It's here, next to the electrified enclosure, that the covert photographer's companions—whose work he literally documented—threw the corpses of the newly gassed victims onto large infernos in the open air, from which there escaped a thick smoke, the same that one can see very clearly in the aerial shots by the RAF.

We know that until the autumn of 1942, the bodies of the Jewish victims of Bunkers I and II were buried. During his visit to Auschwitz on July 17 and 18, 1942, Heinrich Himmler was present at a gassing in Bunker II and the burial of the corpses. But the SS feared the pollution of the water table by the decomposing bodies, which consequently posed new logistical problems for the project of interning one hundred thousand further prisoners at Birkenau. Himmler therefore ordered that the bodies be burned, after the model—put in place by SS Colonel Paul Blobel—of the great infernos of Chelmno. From late September to late November

1942, fifty thousand bodies were burned this way in the free air of the birch wood zone. Filip Müller meticulously reported the digging of new incineration pits opposite crematorium V in the spring of 1944, to handle the enormous enterprise of the extermination of the Hungarian Jews.

Since that time, the pits have been filled in. What I can see near this enclosure of the camp probably resembles the state the ground was in *before* those terrifying contrivances that measured forty to fifty meters in length, eight meters in width, and two meters in depth, contrivances to which were added gutters for collecting human fat. "Absolutely" speaking, there is nothing more to see of all this. But the *afterward* of this history, in which I'm situated today, has for its part continued to *work*, belatedly, "relatively." This is what I realize upon discovering, with an aching heart, the bizarre proliferation of white flowers on the exact spot of the cremation pits.

Georges Bataille once wrote a fine article entitled "The Language of Flowers." In it he turns upside down the comforting value attributed to flowers whenever we choose to ignore their relationship to sexuality, to the eventual dissolution of all things, or to the rotting of roots. Here the paradox is crueler still. For in the end, the exuberance with which the flowers of the fields grow is simply the counterpart to a human hecatomb on which this strip of Polish land has capitalized.

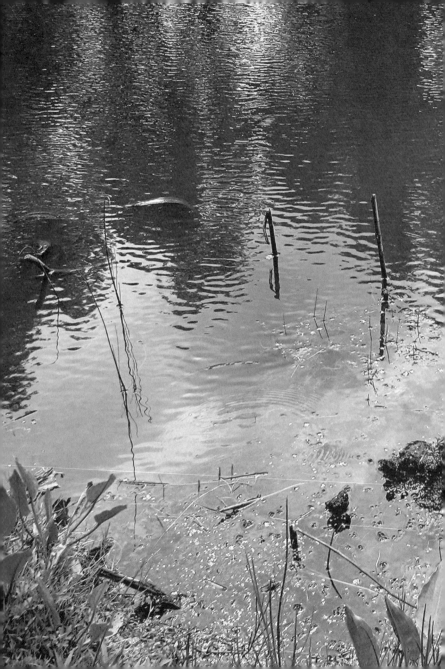

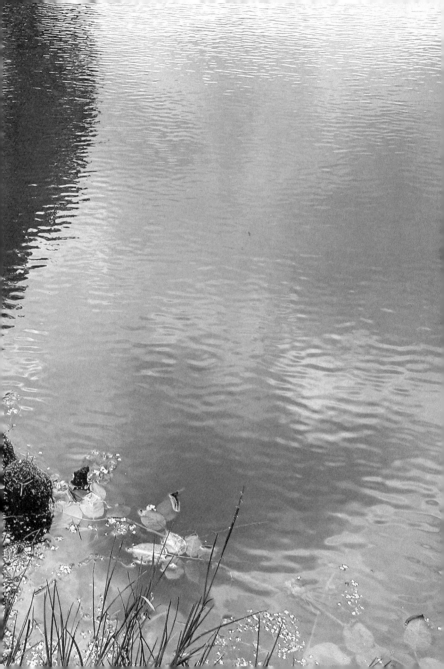

We can therefore never say, "There's nothing to see, there's no more to see." To be able to doubt what we see, we must know how to keep looking, how to see in spite of everything. Despite the destruction, the erasure, of all things. We must know how to look as an archaeologist looks. And it's by way of such a gaze—such an interrogation—directed toward what we see that things begin to look at us from their concealed spaces and bygone time. To walk in Birkenau today is to wander in a peaceful landscape that has been discreetly plotted out—marked out with inscriptions and explanations, documented, in short—by the historians of this *lieu de mémoire*. Given that the terrifying story for which this place served as the theater is a story of the past, one would like to believe what one sees at first, namely, that death has departed, that the dead are no longer here.

Yet little by little, one discovers the contrary. The destruction of people does not mean they are departed. They're here, they are indeed here: here in the flowers of the fields, here in the birches' sap, here in this tiny pond where lie the ashes of thousands dead. A pond, still water that requires our gaze to be on the alert at every instant. The roses placed by the pilgrims on the water's surface are still

floating and begin to rot. The frogs leap up from all around when I approach the water's edge. Below are the ashes. Here one has to understand that one is walking in the largest cemetery in the world, a cemetery whose only "monuments" are the remains of the devices conceived precisely for the murder of each person separately and of all of them together.

The "curators" of this quite paradoxical "State Museum," for that matter, have come up against an unexpected difficulty not easily managed: in the zone surrounding crematoriums IV and V, at the edge of the birch wood, the earth itself is constantly causing the traces of the mass massacres to resurface. The washing of the rains, in particular, has brought countless splinters and fragments of bone back up to the surface, so that those responsible for the site have found themselves obliged to add more earth to re-cover this layer that is still being solicited from below, still living off the massive work of death.

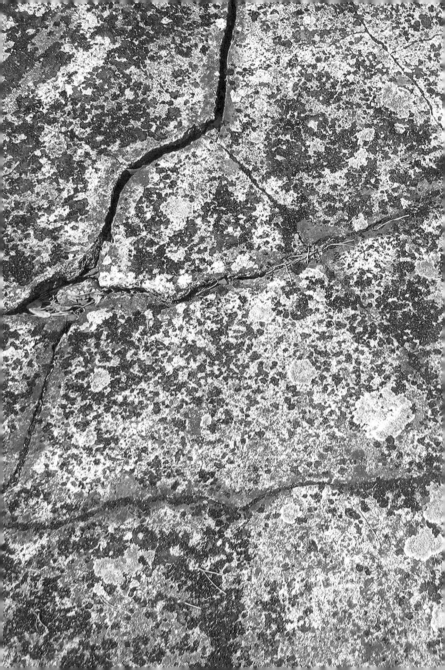

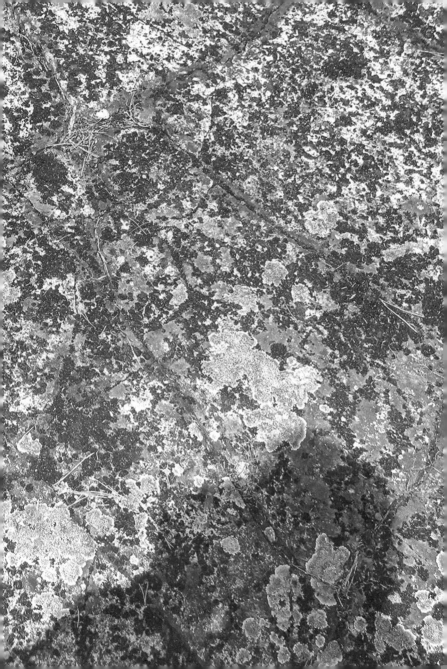

Before leaving, I photographed the floor of crematorium V.
The cement is still just as hard, but cracked and broken in
places. Mosses or lichens have taken possession of the place.
It didn't occur to the Nazis who blew up the building in
order to suppress the "evidence" of their criminal enterprise
to destroy the floors. Nothing resembles one cement floor as
much as a second one. But the archaeologist, as we know,
says otherwise: floors speak to us precisely inasmuch as they
survive, and they survive inasmuch as they are taken to be
neutral, insignificant, inconsequential. But it's for this very
reason that they merit our attention. They are themselves
like the bark of history.

I know that at the sites of certain Nazi camps—most
notably the one at Buchenwald—skilled professional
archaeologists have had to be summoned to interrogate the
floors, to scour the depths, to excavate the remnants of
history. At Birkenau, the floor of Kanada II—a zone no
barracks of which subsists anymore—"still pours forth the
miserable wealth of the SS's victims," as Jean-François Forges
writes in his recent *Guide historique d'Auschwitz*: place
settings, plates, containers of enamel or pewter, fragments
of glasses or bottles.

In a magnificent short text entitled "Excavation and Memory," Walter Benjamin pointed out—following Freud— that an archaeologist's activity could shed light, beyond its material technique, on something essential to the activity of our memory. "He who would approach his own buried past must behave like a man digging. He must not fear returning ceaselessly to the same matter—scattering it as one scatters earth, turning it over as one turns over soil." What he finds, in the ever-*resurfaced* scatterings of lost time, are "those images which, taken out of all prior context, henceforth resemble simply clothed jewels to our eyes, like the torsos in a collector's gallery."

This signifies at least two things. First, that the art of memory is not reducible to the inventory of objects brought to light, objects clearly visible. Second, that archaeology is not only a technique for exploring the past, but also and above all an anamnesis for understanding the present. This is why the art of memory, Benjamin says, is an "epic and rhapsodic" art: "In the strictest sense, the true memory should thus simultaneously yield an image, in an epic and rhapsodic mode, of the one who is remembering, just as a proper archaeological report should indicate not only the layers in which the discoveries were made, but also, and above all, those through which it was necessary to go beforehand." I therefore don't claim, looking at this floor, to reveal all that it hides. I simply interrogate the layers of time through which I'll have had to go beforehand in order to get

to it. And in order that it may rejoin, in this very place, the movement—the anxiety—of my own present.

What the bark tells me of the tree. What the tree tells me of the wood. What the wood, the birch wood, tells me of Birkenau. This image, of course, like the others, is almost nothing. Quite a little thing, a superficial thing: film, silver salts that are deposited, pixels that materialize. Always entirely on the surface and through intermediary surfaces. Technical surfaces to testify only to the surface of things. What does this tell me deep down, what does this reach deep down? The majority of images, I'm well aware, remain without consequences. Thousands of tourists before me have come to Birkenau, camera in hand, and a thousand times already they have focused their lens, I imagine, exactly where I focused mine. To each his album, one might say. These images, in general, become private treasures; like dream images, they are neither intense nor significant, save in the personal memory of the one who cherishes them.

But not all images remain without shared consequences. Some images—like those of the *Sonderkommando* of Birkenau—are collective acts, not simple trophies or private trinkets. There are surfaces that transform the depth of things around them. The philosophers of the pure idea, the mystics of the Holy of Holies think of the surface as merely a

disguise, a lie: *that which conceals* the true essence of things. Appearance versus essence, or semblance versus substance, in short. One can think, on the contrary, that the substance said to transcend all surfaces is nothing but a metaphysical illusion. One can think that the surface is *that which falls* from things: that which comes from them directly, which detaches itself from them, which thus proceeds from them. And which detaches itself from them to come and linger in wait for us, beneath our gaze, like strips of bark from a tree. As long as we are willing to bend down to pick up some of the pieces.

The bark is no less true than the trunk. It is even through the bark, if I can put it this way, that the tree expresses itself. Presents itself to us, in any case. Appears through apparition, and not just through its appearances. Bark is irregular, discontinuous, uneven. Here it clings to the tree, there it disintegrates and falls into our hands. It's the impurity that comes from things themselves. It tells of the impurity—the contingency, the variety, the exuberance, the relativity—of all things. It lies somewhere in the interface between a transient appearance and a lasting inscription. Or else it designates precisely the inscribed appearance, the lasting transience of our own life decisions, of our experiences undergone or undertaken.

What did I go to do at Birkenau? Why "go back to that"? I remember wandering uncertainly, though in a manner evidently oriented by knowledge built up since childhood. I

walked through the birch wood without any plan, and yet I walked in an imperious direction. All this in a vacillating yet deeply affected state of mind, more withdrawn than I might at first have imagined, despite being wholly prevailed upon by the violence of the place. I felt the particular air of that Sunday in summer, the space's unpredictable scale, the heaviness of the sky. I looked at the trees as one interrogates silent witnesses. I tried to minimize my resentment of those poor, cruel flowers. As I walked, I reinscribed this place within my family history: my grandparents who died here, my mother who thereby lost all means of telling, my sister who loved Poland at a time when I couldn't understand it, my cousin who isn't yet ready, I don't imagine, for this kind of head-on reunion with history. I thought of my friend, a Polish Jew, who at that same moment was dying at the other end of Europe.

So as to be neither dazzled nor overwhelmed, I did as everyone does: I took some haphazard photographs. Almost haphazard, shall we say. Having returned home, I found myself faced with these few pieces of bark, this sign of painted wood, this souvenir shop, this bird between barbed wires, this dummy firing wall, these very real floors cracked by the work of death and of time since passed, this watchtower window, this strip of wasteland announcing hell, this dirt track between two electrified enclosures, this barracks door, these few tree trunks and these high boughs in the birch wood, this row of flowers opposite crematorium V,

this pond filled with human ashes. A few images are nothing at all for such a history. But they are to my memory what a few pieces of bark are to a single tree trunk: pieces of skin, already flesh.

In French, the word *écorce* is said by etymologists to represent the medieval product of the imperial Latin word *scortea*, which means "coat of skin." As if to make clear that an image, if one experiments in thinking of it as bark, is at once a coat—a costume, a veil—and a skin, which is to say a surface of apparition endowed with life, reacting to pain and destined to die. Classical Latin has produced a precious distinction: there are not one, but two barks. There is first of all the epidermis, or *cortex*. This is the part of the tree immediately to hand at the exterior, and it is this that one cuts, that one "decorticates," to begin with. The Indo-European origin of this word—which one finds in the Sanskrit terms *krtih* and *krttih*—denotes both the skin and the knife that wounds or removes it. In this sense, *écorce* designates that introductory part of the body liable to be affected, scarred, cut up, separated first.

For precisely that part where the bark adheres to the trunk—the dermis, in a way—the Latin peoples invented a second word that provides the exact other face of the first: the word *liber*, which designates the part of the bark that serves even more easily than the *cortex* itself as a writing material. It therefore naturally gave its name to those things so necessary for inscribing the strips of our memories: those

things made of surfaces, of cut-up pieces of cellulose, extracted from trees, where words and images meet. Those things that fall from our thought and are called books (*livres*). Those things that fall from our skinnings (*écorchements*), those barks of images and texts arranged and phrased together.

(July 2011)